DRAW, MODEL, & PAINT

MONSTERS and EXTRATERRESTRIALS

by Isidro Sánchez
Models by Elisabet Morgui
Photographs by Juan Carlos Martínez

Gareth Stevens Publishing
MILWAUKEE

For a free color catalog describing Gareth Stevens' list of high-quality books,
call 1-800-542-2595 (USA) or 1-800-461-9120 (Canada).
Gareth Stevens' Fax: 414-225-0377.

Library of Congress Cataloging-in-Publication Data

Sánchez, Isidro.
 [Monstruos y extraterrestres. English]
 Monsters and extraterrestrials / text by Isidro Sánchez ; models by Elisabet Morgui ;
photography by Juan Carlos Martínez.
 p. cm. — (Draw, model, and paint)
 Includes index.
 Summary: Provides instructions for creating models of the Loch Ness monster, King
Kong, Frankenstein, The Mummy, Count Dracula, and several extraterrestrial creatures.
 ISBN 0-8368-1520-3 (lib. bdg.)
 1. Handicraft—Juvenile literature. 2. Monsters in art—Juvenile literature. 3. Life on
other planets in art—Juvenile literature. [1. Modeling. 2. Handicraft. 3. Monsters in
art.] I. Morgui, Elisabet. II. Martínez, Juan Carlos, 1944- ill. III. Title. IV. Series.
TT160.S177 1996
745.592—dc20 95-43912

This North American edition first published in 1996 by
Gareth Stevens Publishing
1555 North RiverCenter Drive, Suite 201
Milwaukee, Wisconsin 53212, USA

Original edition © 1995 Ediciones Este, S.A., Barcelona, Spain, under the title
Monstruos Y Extraterrestres. Text by Isidro Sánchez. Models by Elisabet Morgui.
Photography by Juan Carlos Martínez. All additional material supplied for this
edition © 1996 by Gareth Stevens, Inc.

Series editor: Barbara J. Behm
Editorial assistants: Jamie Daniel, Diane Laska, Rita Reitci

Printed in the United States of America

1 2 3 4 5 6 7 8 9 99 98 97 96

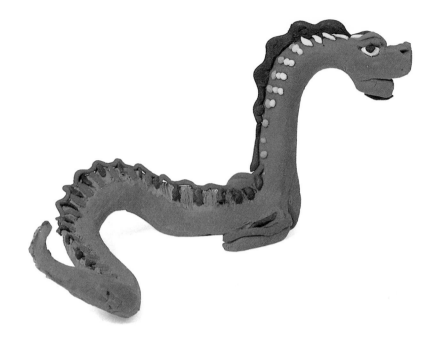

CONTENTS

Loch Ness Monster

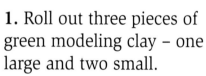

You will need:
- modeling clay
- a palette knife
- toothpicks

Some people believe the Loch Ness Monster lives in a lake in Scotland. Travelers have told of seeing "Nessie" as it momentarily lifts its long, dragonlike body up from the water.

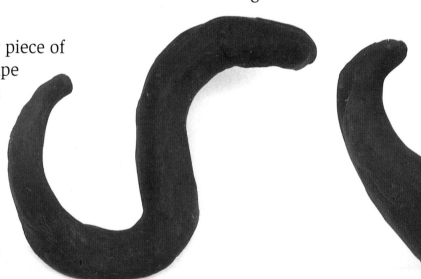

1. Roll out three pieces of green modeling clay – one large and two small.

2. Mold the larger piece of clay into the shape of the monster's head and upper body. Mold a small piece of clay into the lower body. Mold the other small piece into the tail.

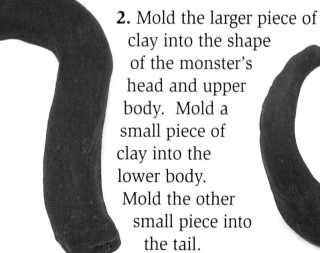

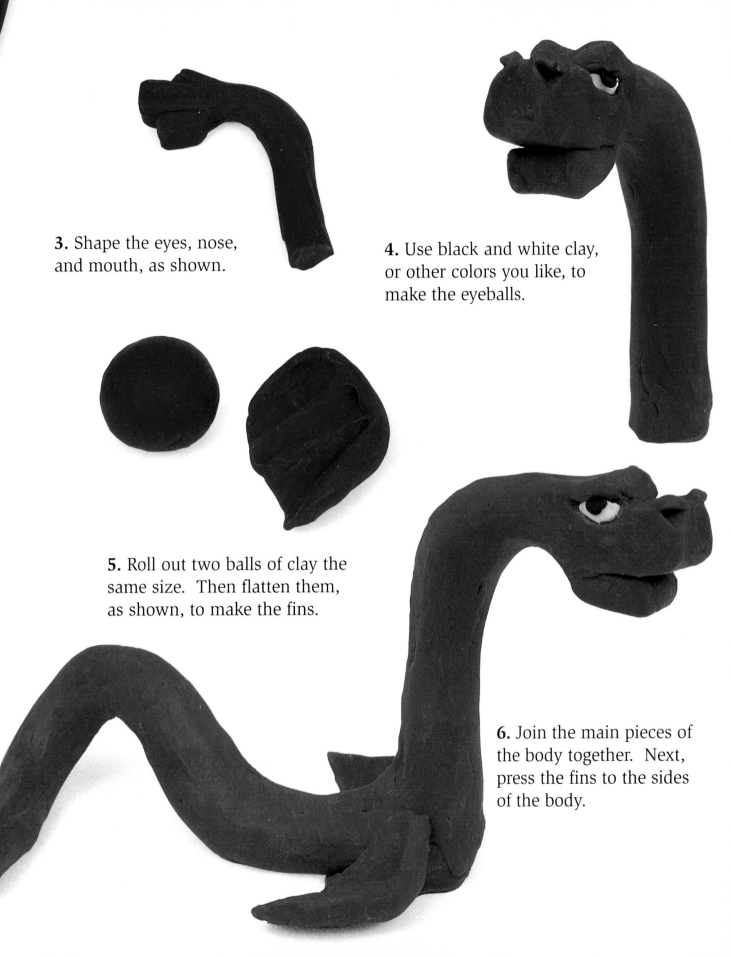

3. Shape the eyes, nose, and mouth, as shown.

4. Use black and white clay, or other colors you like, to make the eyeballs.

5. Roll out two balls of clay the same size. Then flatten them, as shown, to make the fins.

6. Join the main pieces of the body together. Next, press the fins to the sides of the body.

9. Continue decorating Nessie with different colors of clay in any shapes you like.

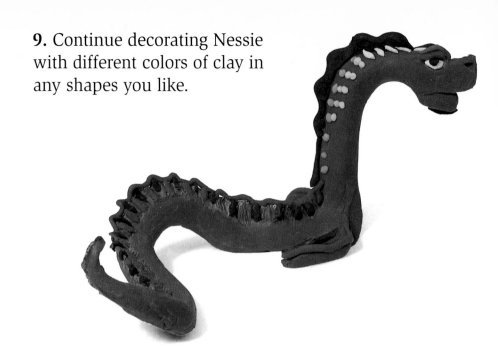

8. Roll out tiny balls of clay, as shown. Press them on the monster's neck.

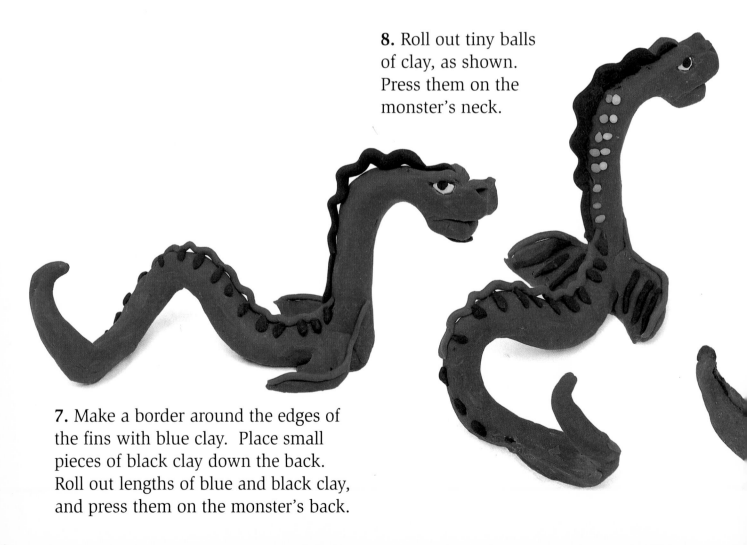

7. Make a border around the edges of the fins with blue clay. Place small pieces of black clay down the back. Roll out lengths of blue and black clay, and press them on the monster's back.

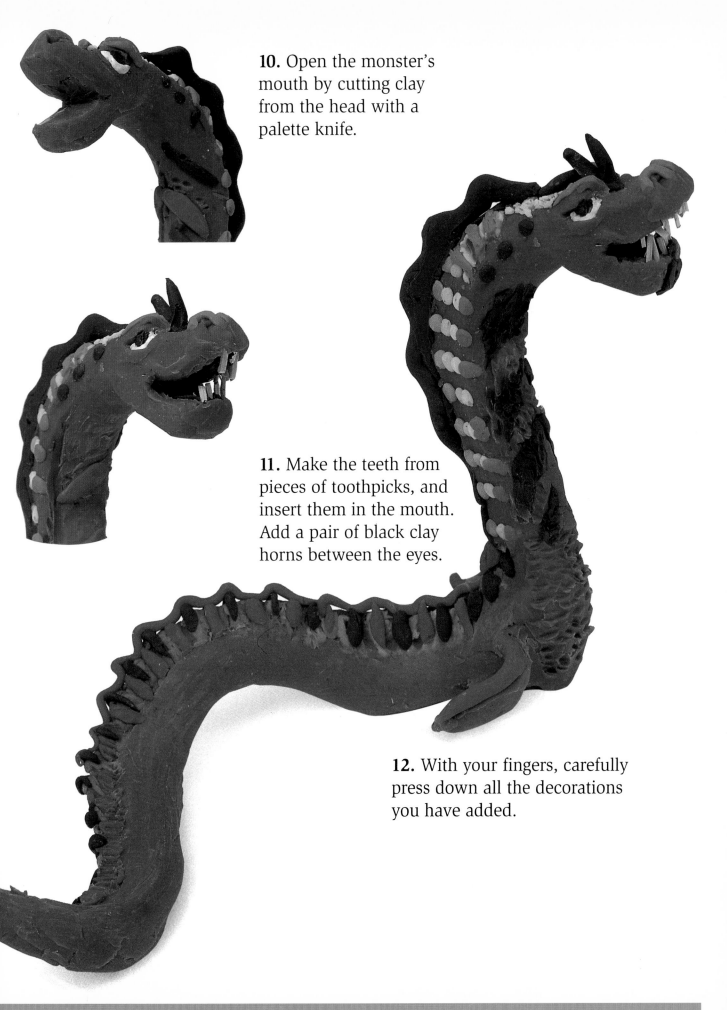

10. Open the monster's mouth by cutting clay from the head with a palette knife.

11. Make the teeth from pieces of toothpicks, and insert them in the mouth. Add a pair of black clay horns between the eyes.

12. With your fingers, carefully press down all the decorations you have added.

King Kong

You may have seen King Kong, the giant gorilla, in the movies.

Some pieces of King Kong will be made separately from the body. These pieces will then be attached to the body with a substance called "slip." Slip is made by mixing small chunks of clay with water until a paste forms.

You will need:
- modeling clay
- a palette knife
- a container for mixing slip
- a container for mixing paints
- a paintbrush
- tempera paints

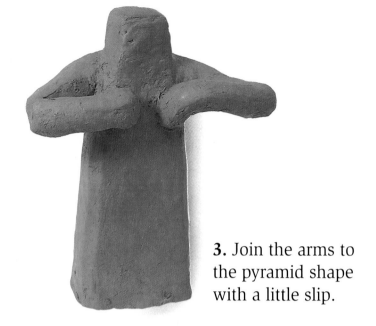

3. Join the arms to the pyramid shape with a little slip.

2. To make the gorilla's arms, roll out two strips of clay. Then, bend the arms at the elbows.

1. Shape a large piece of brown modeling clay into a pyramid. Smooth it, as shown, by cutting off the sides with a palette knife.

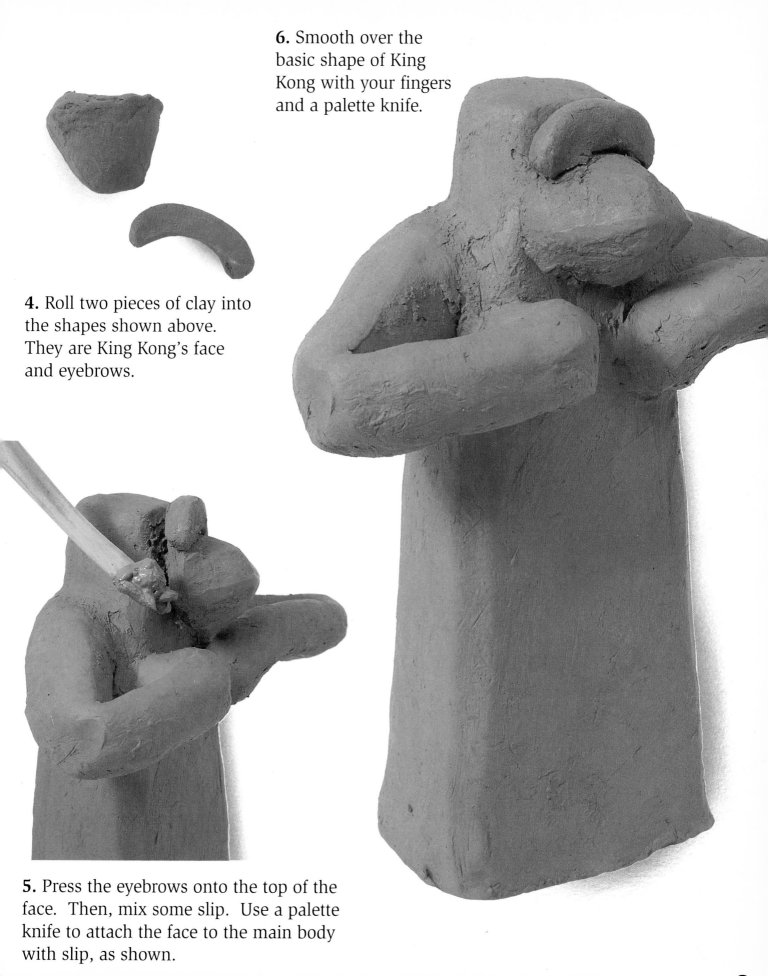

6. Smooth over the basic shape of King Kong with your fingers and a palette knife.

4. Roll two pieces of clay into the shapes shown above. They are King Kong's face and eyebrows.

5. Press the eyebrows onto the top of the face. Then, mix some slip. Use a palette knife to attach the face to the main body with slip, as shown.

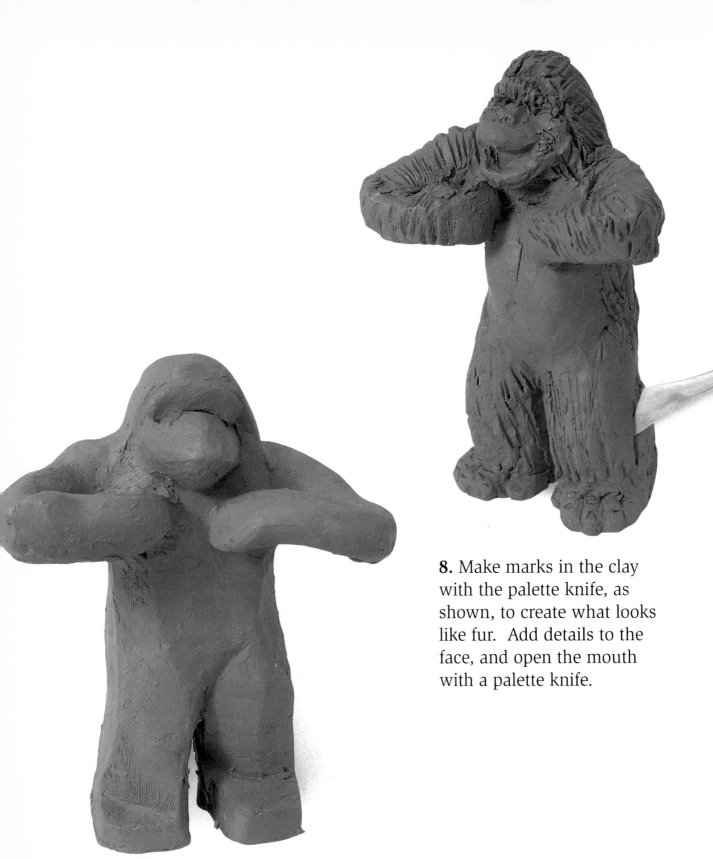

8. Make marks in the clay with the palette knife, as shown, to create what looks like fur. Add details to the face, and open the mouth with a palette knife.

7. Use a palette knife to cut away a section of clay to create the legs, as shown.

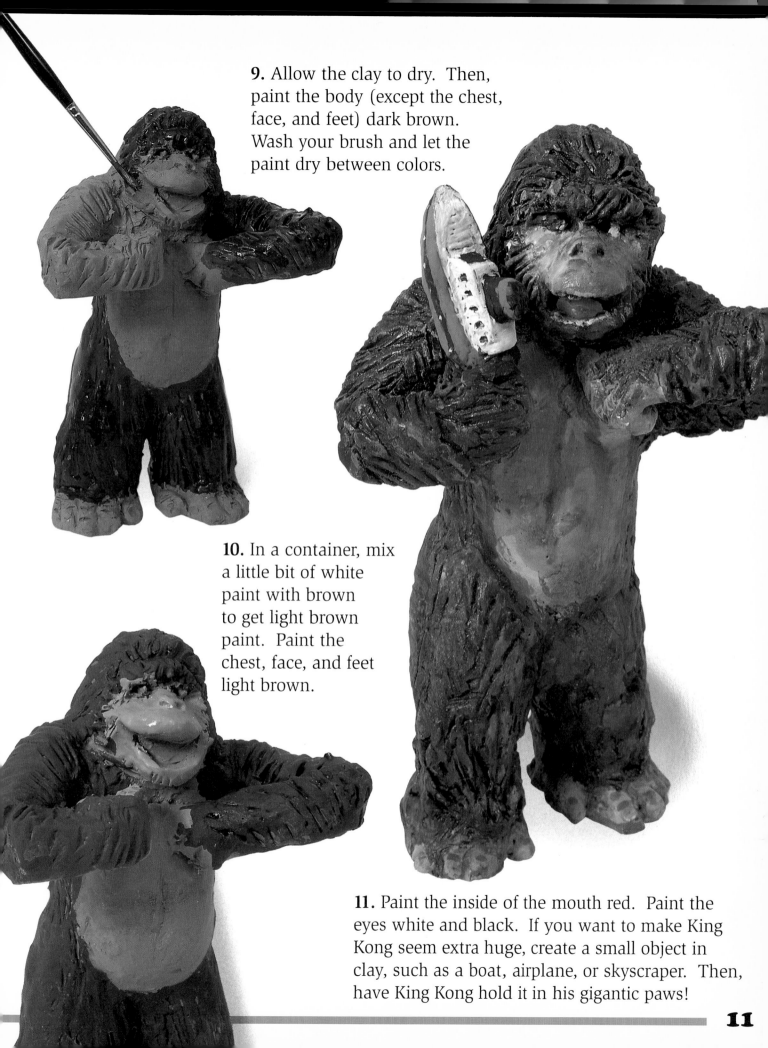

9. Allow the clay to dry. Then, paint the body (except the chest, face, and feet) dark brown. Wash your brush and let the paint dry between colors.

10. In a container, mix a little bit of white paint with brown to get light brown paint. Paint the chest, face, and feet light brown.

11. Paint the inside of the mouth red. Paint the eyes white and black. If you want to make King Kong seem extra huge, create a small object in clay, such as a boat, airplane, or skyscraper. Then, have King Kong hold it in his gigantic paws!

Frankenstein

One of the most famous monsters of all time is Frankenstein. The monster was created in 1818 by author Mary Wollstonecraft Shelley in her fictional book, *Frankenstein*. Many horror movies have been based on the book, particularly the 1931 version that featured Boris Karloff as the monster.

2. With a white colored pencil, draw the jacket and sleeves on black posterboard, using the pattern above. Cut the items out.

1. With a pencil, draw the monster's trousers and shoes on white posterboard, as shown in the pattern at right. Color them with colored pencils. Then cut the pattern out.

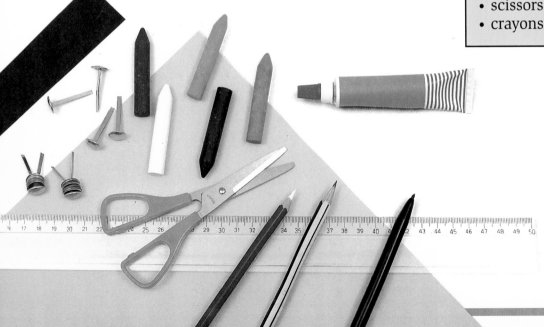

You will need:
- posterboard
- a pencil
- a ruler
- scissors
- crayons
- colored pencils
- a black marker
- paper fasteners
- glue

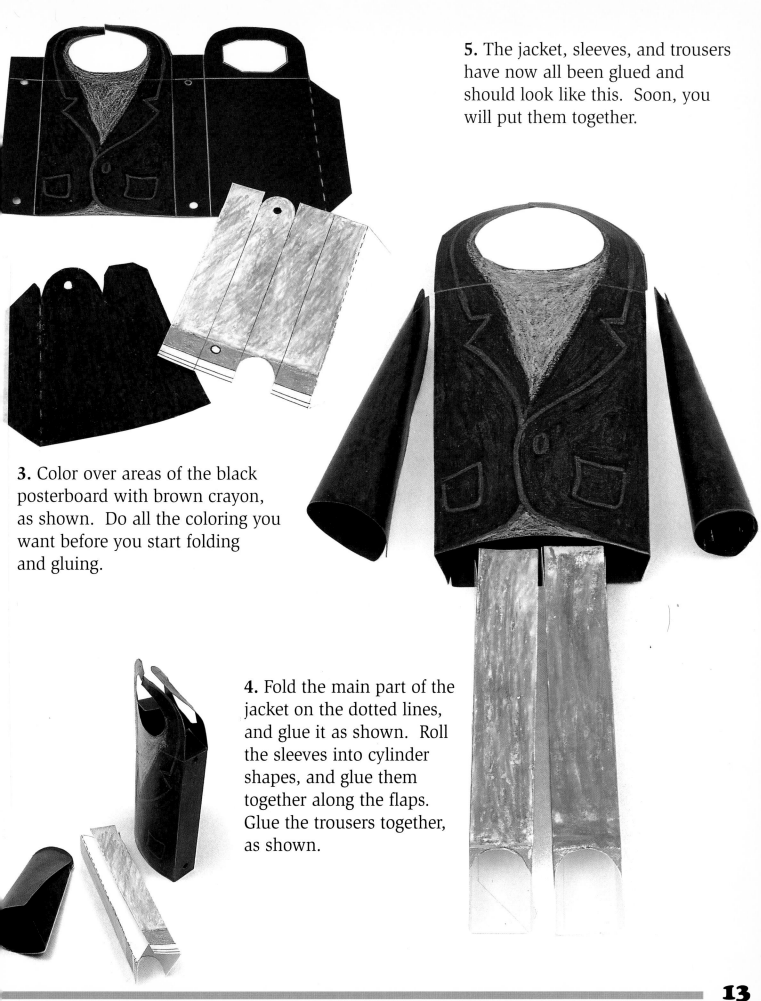

5. The jacket, sleeves, and trousers have now all been glued and should look like this. Soon, you will put them together.

3. Color over areas of the black posterboard with brown crayon, as shown. Do all the coloring you want before you start folding and gluing.

4. Fold the main part of the jacket on the dotted lines, and glue it as shown. Roll the sleeves into cylinder shapes, and glue them together along the flaps. Glue the trousers together, as shown.

6. Draw the hair, head, and hands on green posterboard. Mark two small crosses on either side of the head, as shown. Color in the black areas. Cut the pieces out.

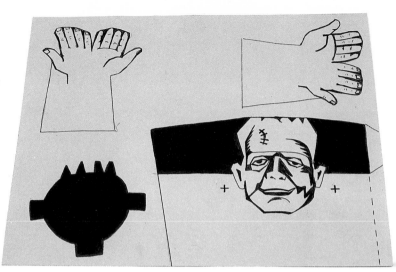

8. Make holes in the crosses marked on the head, and put a paper fastener, like the one shown, in each hole. Open each fastener so the prongs are inside the head. Roll the head into a cylinder shape, and glue it along the flap. Then, glue the hair on.

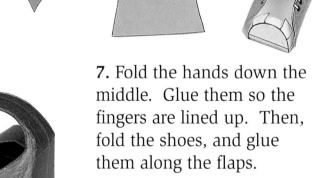

7. Fold the hands down the middle. Glue them so the fingers are lined up. Then, fold the shoes, and glue them along the flaps.

9. Join the jacket sleeves to the jacket with paper fasteners, as shown.

10. Insert the shoes into the trouser bottoms, and glue them in place. Join the two legs together with a paper fastener, as shown.

12. Place the head in the hole at the top of the jacket. It should fit snugly without needing glue.

11. Insert paper fasteners at the bottoms of the jacket sides. Use them to attach the trousers to the jacket. Next, glue the hands inside the sleeves.

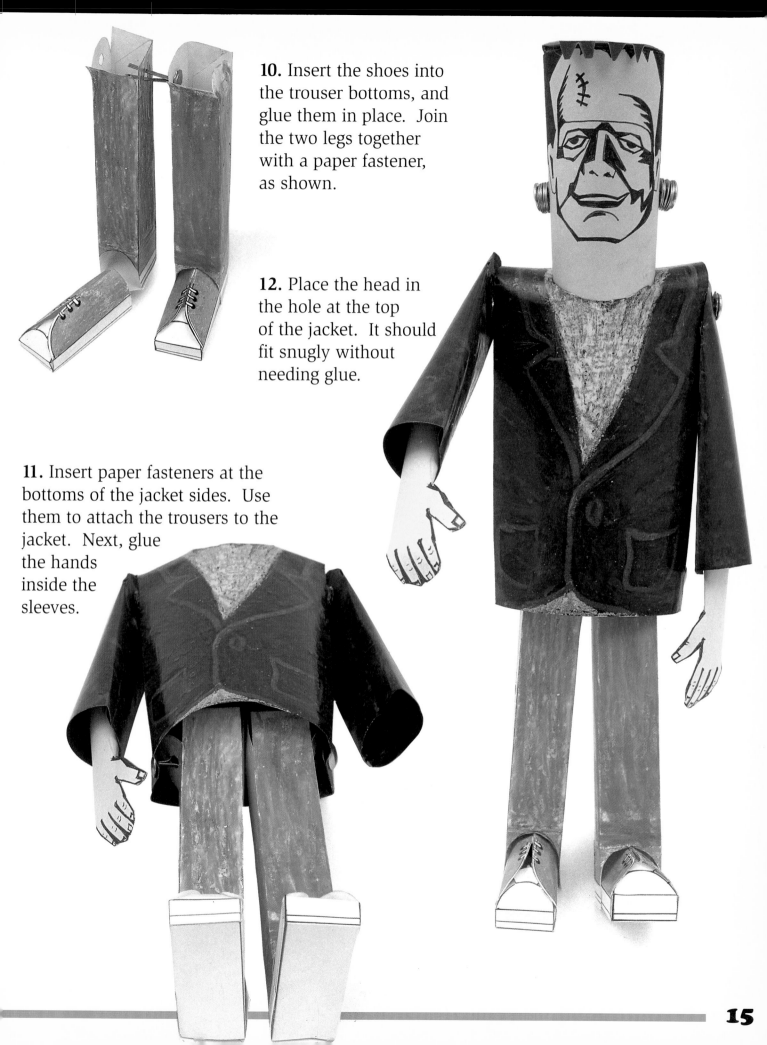

The Mummy

The Mummy is a frightening creature you may be familiar with from old black-and-white movies.

The ancient Egyptians embalmed their dead and then wrapped them in specially treated cloth to "mummify" them. The dead body of the person or animal would then be preserved throughout time. This was important to the ancient Egyptians because they believed the spirit of the dead body would return to it.

You will need:
- wire
- newspaper
- modeling clay in various colors
- narrow, white gauze
- art paste (from an art supply store)
- a palette knife

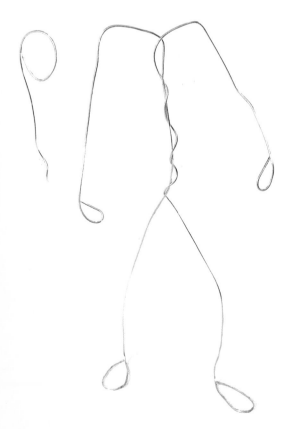

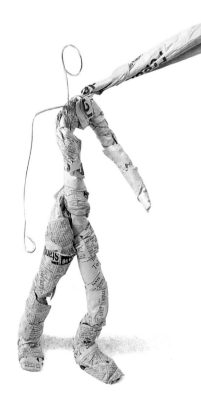

1. Have an adult help you carefully twist two long pieces of wire together, as shown, to form the Mummy's body. Next, make the head from a shorter piece of wire, and attach it to the body.

2. Wind a long, narrow strip of rolled-up newspaper around the wire, starting at one foot. Use several strips until all the wire is covered.

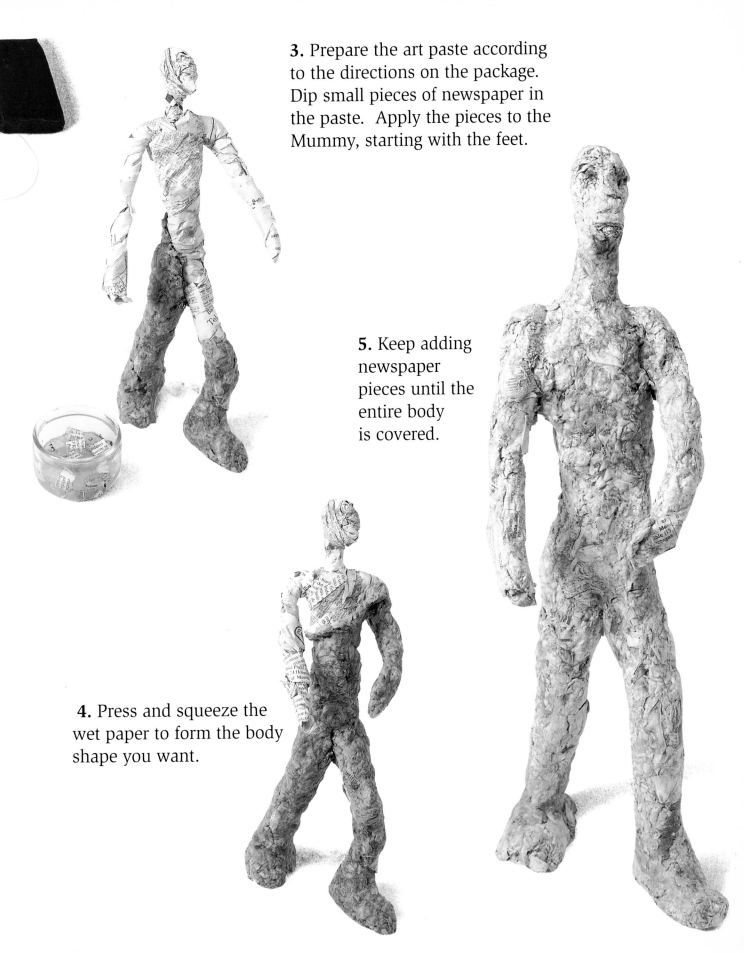

3. Prepare the art paste according to the directions on the package. Dip small pieces of newspaper in the paste. Apply the pieces to the Mummy, starting with the feet.

5. Keep adding newspaper pieces until the entire body is covered.

4. Press and squeeze the wet paper to form the body shape you want.

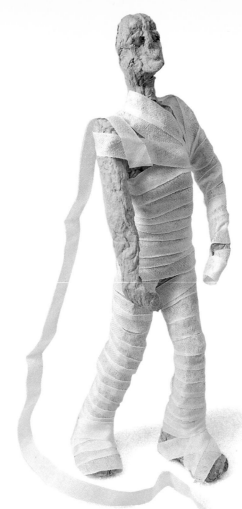

7. Wind the gauze around the body, beginning with one of the feet. Do not cover the eyes. Place two small balls of red modeling clay into the eye sockets.

6. Be especially careful when you shape the head. Squeeze the paper to form a long, thin neck. Hollow out the eyes, mouth, and cheekbones with a palette knife.

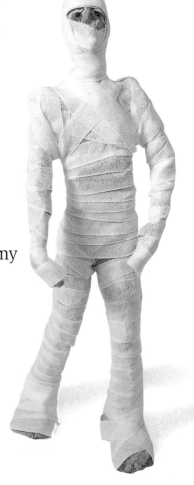

8. Your mummy is starting to come to life!

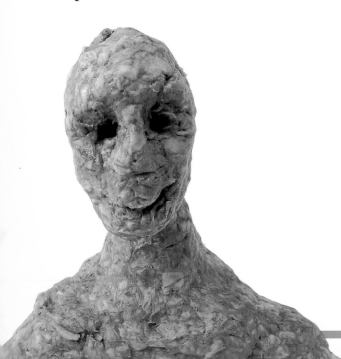

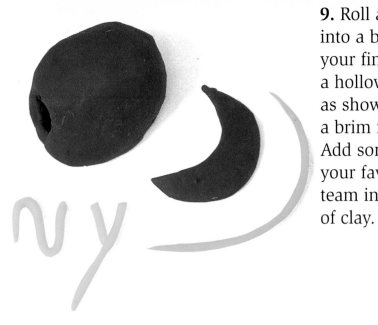

9. Roll a piece of modeling clay into a ball. Press it with your fingers to make a hollow hat shape, as shown. Make a brim for the hat. Add some letters of your favorite baseball team in another color of clay.

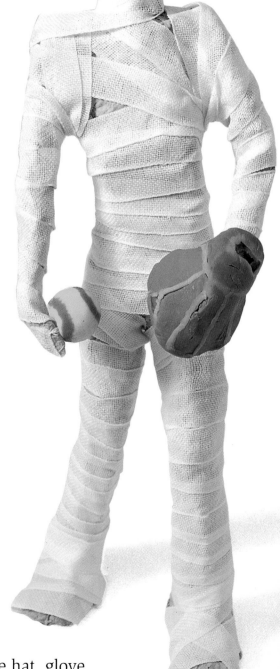

10. Make a baseball glove out of brown modeling clay, as shown. Decorate it with orange clay.

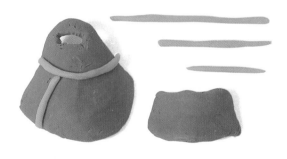

11. Make a baseball out of yellow clay. Use brown clay for the seams.

12. Place the hat, glove, and ball on the Mummy.

An extraterrestrial

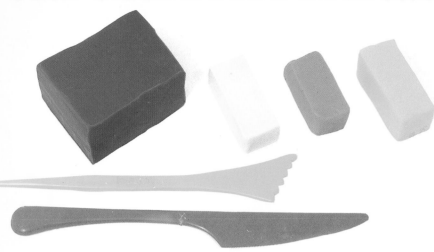

Extraterrestrial refers to any life form that may exist beyond our planet Earth.

Perhaps this little green man lives on another planet, but he could easily become your favorite toy right here on Earth!

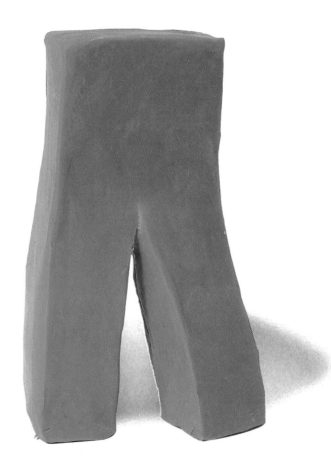

1. Divide a large piece of green modeling clay almost completely in half, as shown. Bend one of the legs forward a little.

2. Roll out a small ball of green clay for the head. Use two smaller pieces to make the neck and point at the back of the head.

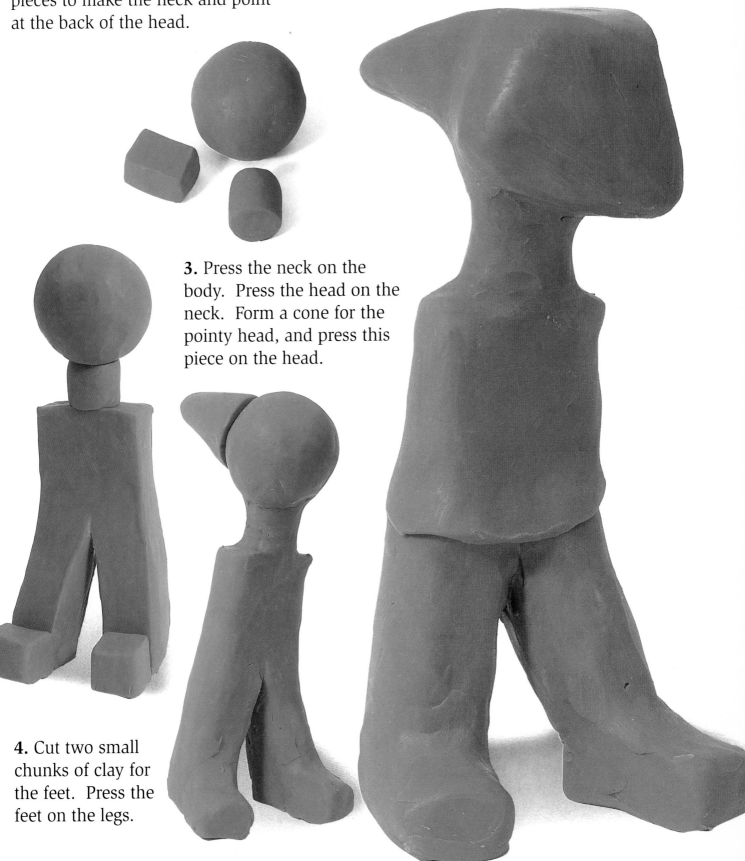

5. With a palette knife, smooth over and form the extraterrestrial into a shape like this.

3. Press the neck on the body. Press the head on the neck. Form a cone for the pointy head, and press this piece on the head.

4. Cut two small chunks of clay for the feet. Press the feet on the legs.

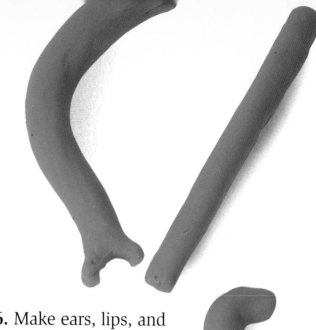

6. Make ears, lips, and arms from the clay. Roll out the clay until the pieces are the right lengths and thicknesses.

7. Press the arms onto the body. Join the end of one arm to the waist, as shown.

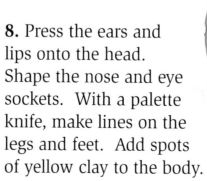

8. Press the ears and lips onto the head. Shape the nose and eye sockets. With a palette knife, make lines on the legs and feet. Add spots of yellow clay to the body.

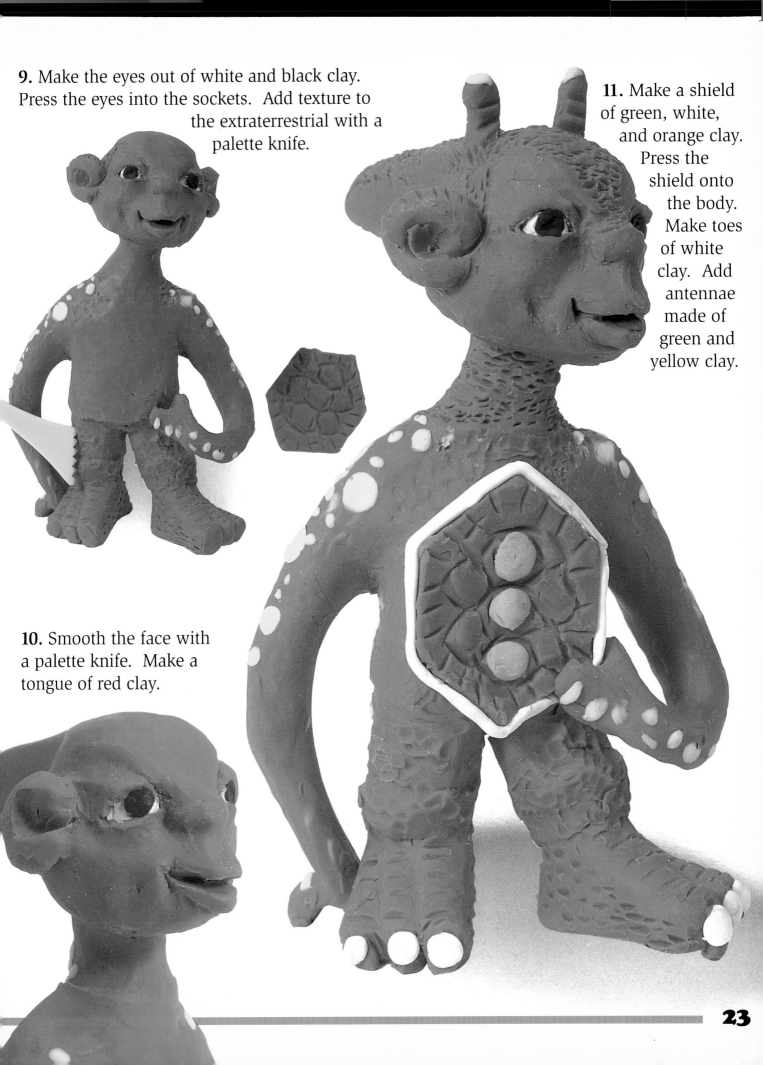

9. Make the eyes out of white and black clay. Press the eyes into the sockets. Add texture to the extraterrestrial with a palette knife.

11. Make a shield of green, white, and orange clay. Press the shield onto the body. Make toes of white clay. Add antennae made of green and yellow clay.

10. Smooth the face with a palette knife. Make a tongue of red clay.

A space creature

It is rumored that clay creatures from outer space have arrived on Earth in their spaceships and are wandering our planet. One of them could come to live with you!

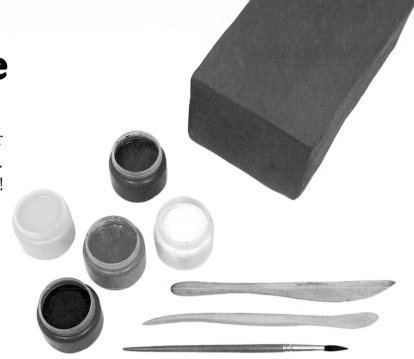

1. With a palette knife, draw the profile, or side, of your space creature on one of the wider sides of a block of clay, as shown. If you make a mistake or change your mind as you draw, just rub out the mistake and start over.

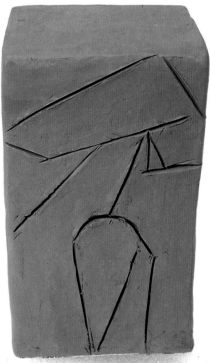

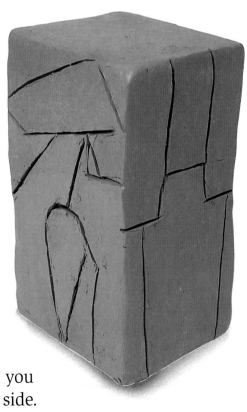

2. Draw the front of the creature on the narrow side of the block, as shown. Make sure the marks line up with what you have drawn on the wide side.

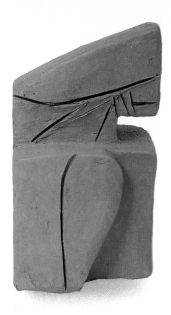

3. Cut away unwanted clay with a palette knife. To do this, follow the lines you have made in the clay block, and take out the unwanted clay.

5. Cut away any unwanted clay from the creature's back and head.

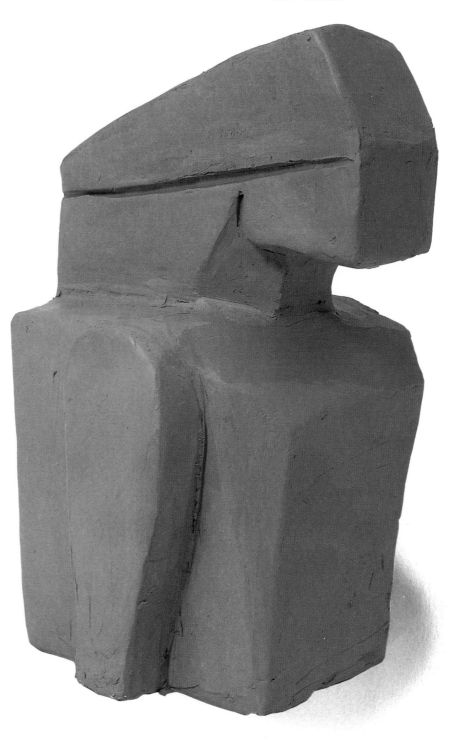

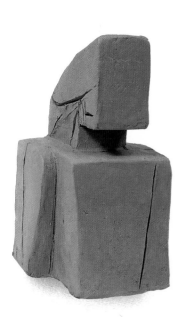

4. This is how the block will look from the front.

6. Make the mouth by cutting away clay, as shown, with a palette knife. Make the ribs in the same way.

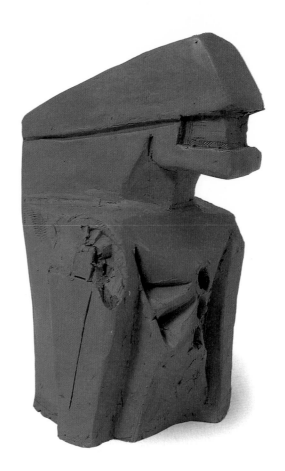

8. Smooth the clay with a palette knife. Use the knife to draw in muscles and tendons on the creature's neck and arms.

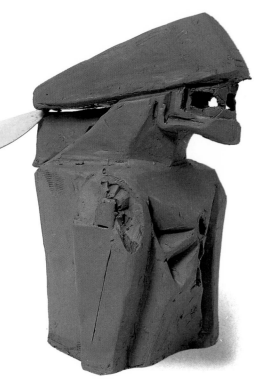

7. Finish the outline of the neck by removing any unwanted clay still there.

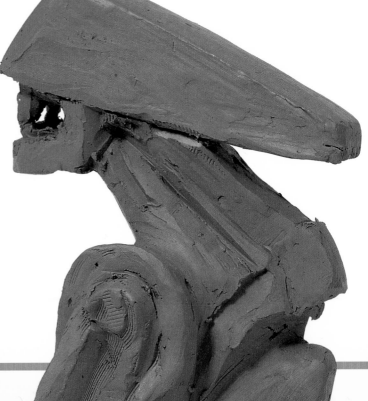

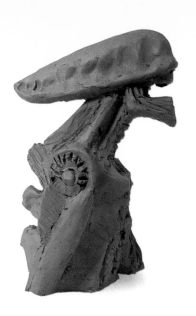

9. With the palette knife, make small dents on both sides of the head. Draw lines with the knife to add texture to the creature's skin.

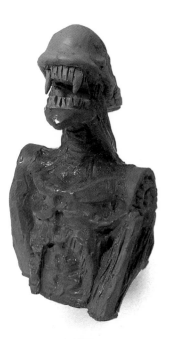

10. Form teeth with the palette knife as shown. Then, let the clay dry. After it dries, paint the body, except for the head, blue. Always wash your brush between colors.

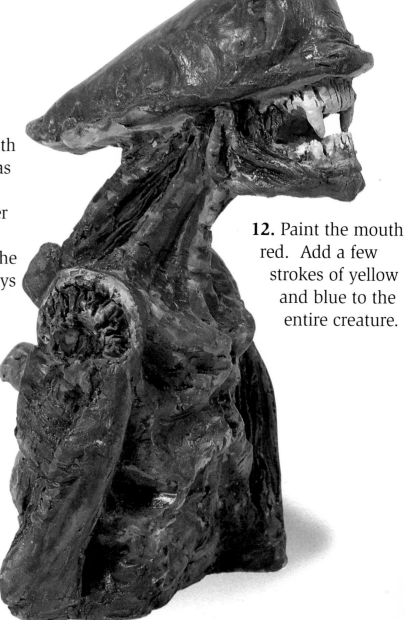

12. Paint the mouth red. Add a few strokes of yellow and blue to the entire creature.

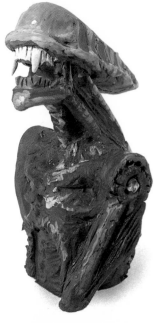

11. Mix white paint with dark green to make a light green paint. Paint areas of the head and neck light green. Mix white paint with red to make pink paint. Paint the top part of the head pink. Paint the teeth white.

A Dracula mobile

In folklore, a vampire is an evil ghost or spirit that takes over a dead body. The vampire then rises from the grave and sucks the blood from people. These people become vampires when they die. According to folklore, a vampire can only be killed by pounding a wooden stake into its heart. Count Dracula, the most famous vampire of all time, can be the star of a terrifying mobile to decorate your room.

1. With a pencil, draw Dracula, as shown below, on posterboard. When you have the drawing the way you want it, draw over the lines with a black felt-tip pen.

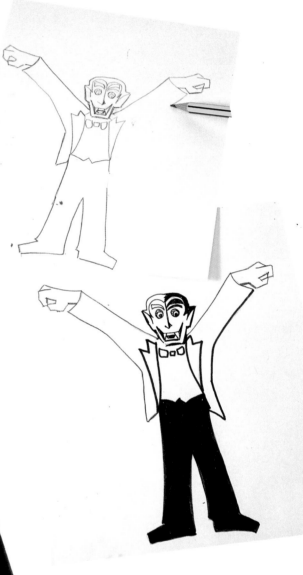

You will need:
- white posterboard
- scissors
- a black felt-tip pen
- black and red tissue paper
- flat toothpicks
- black thread
- two strong sticks
- a pencil
- glue

3. To make the cape, cut out two 6-inch (15-centimeter) squares of red tissue paper. Then, make a diagonal cut in each square, halfway across, and fold the squares, as shown. Glue toothpicks to one of the squares, and glue the squares together.

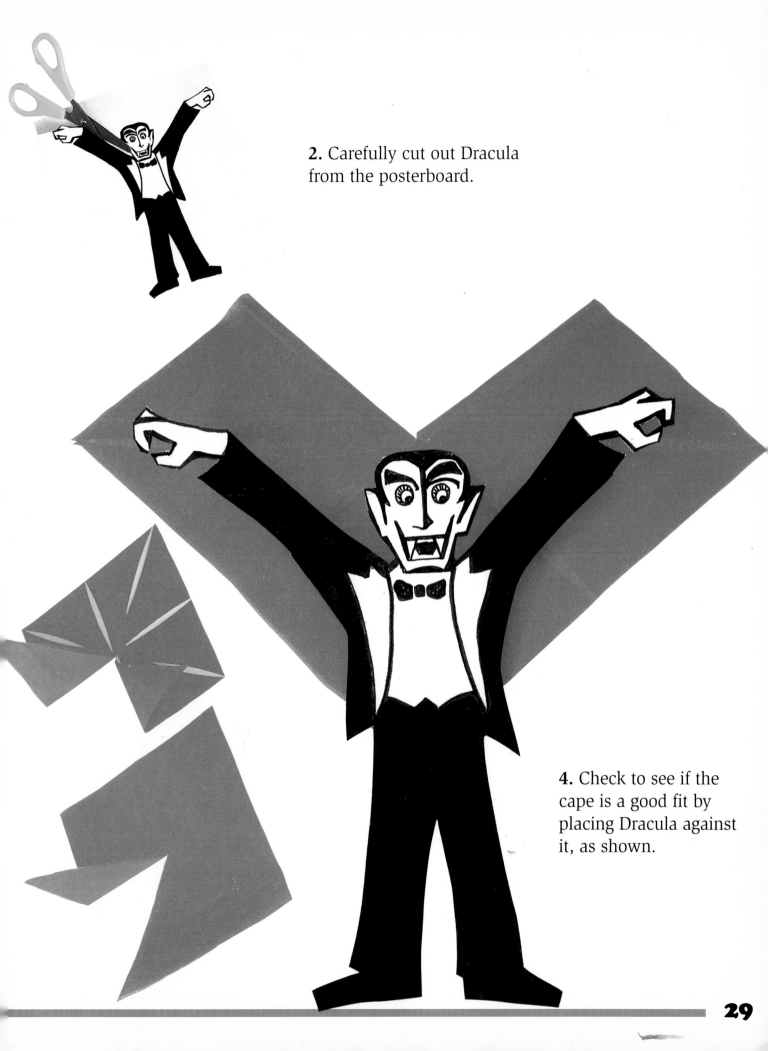

2. Carefully cut out Dracula from the posterboard.

4. Check to see if the cape is a good fit by placing Dracula against it, as shown.

5. Cut out squares of black tissue paper that are slightly bigger than the red ones. Make diagonal cuts in the black paper, and glue the black squares over the red squares.

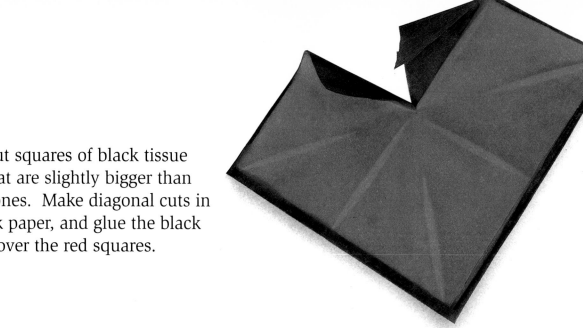

7. If you like, make the capes of the other Draculas in different shapes. To change the shapes, fold the paper differently. You could also make the capes different colors.

6. Glue Dracula's arms to the cape. Fold the top corners of the black squares over Dracula's arms, and glue the edges, as shown. Make three more Draculas to complete the mobile.

8. Fasten two large sticks together and attach a thread, as shown. With various lengths of thread, hang your Draculas from the large sticks. Hang the mobile securely from the ceiling of your bedroom. When somebody opens your door or when the wind blows through the window, the Draculas will fly!

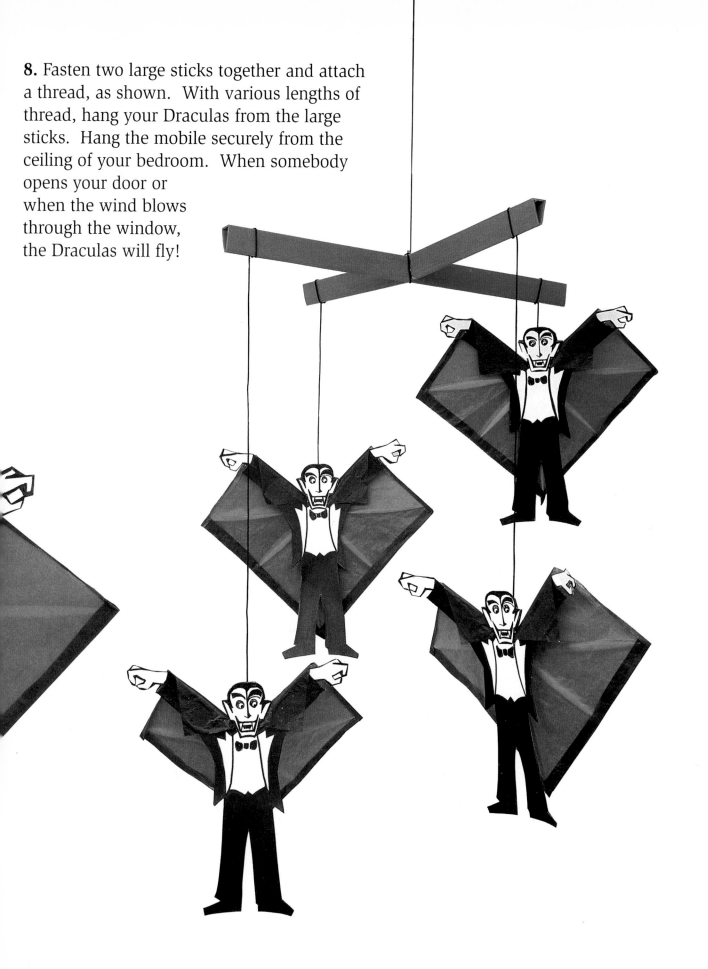

Glossary

antennae: thin organs on an insect's (or extraterrestrial's!) head that are used for touching and smelling.

cylinder: an object shaped like a tube.

embalm: to treat a dead body with substances that will slow or stop it from deteriorating.

extraterrestrial: a being whose origin is outside Earth's atmosphere.

folklore: the beliefs and legends handed down by a culture from one generation to the next.

mobile: a sculpture that is made of parts that sway back and forth.

mummify: to treat and wrap a dead body. In ancient times, the mummy was then placed in a case and sealed in a tomb.

palette knife: a flat, knifelike tool used in sculpting and modeling. It is usually made of plastic or wood.

profile: a view of an object from the side.

pyramid: an object that has a flat base and three or more triangular sides that meet at the top.

slip: a substance used to bond pieces of clay together. It is made by mixing small chunks of clay with water until a paste forms.

tempera paints: paints that are mixed with water before use.

texture: the look or feel of a surface.

Books and Videos for Further Study

Aliens and Extraterrestrials - Are We Alone? Asimov (Gareth Stevens)

Dracula. Stoker (Puffin Books)

Frankenstein. Shelley (Random House Books for Young Readers)

Horrorigami: Spooky Paperfolding Just for Fun. Saunders (Sterling)

Mobiles. Building and Experimenting with Balancing Toys. Zubrowski (Morrow Junior Books)

Monster Myths. The Truth about Water Monsters. Rabin (Watts)

Worldwide Crafts (series). Deshpande and MacLeod-Brudenell (Gareth Stevens)

Mummies Made in Egypt. (Reading Rainbow Video)

My Pet Monster. (Hi-Top Video)

Tell Me Why: Space, Earth and Atmosphere. (Prism Video)

Index